Flowers

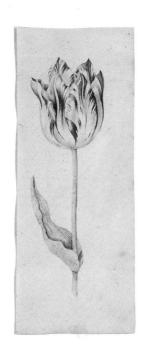

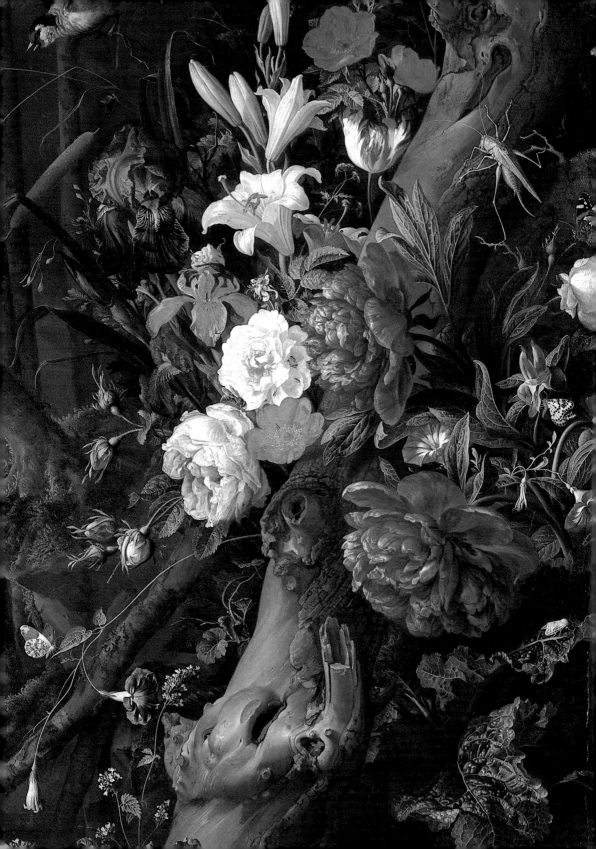

THEMES IN ART

Flowers

PETER MITCHELL

SCALA BOOKS

First published 1992
by Scala Publications Limited
3 Greek Street
London W1V 6NX

in association with
Réunion des Musées Nationaux
49 rue Etienne Marcel
Paris 75039

Distributed in the USA and Canada by
Rizzoli International Publications, Inc.
300 Park Avenue South
New York
NY 10010

ISBN 1 85759 011 2

Designed by Roger Davies
Edited by Paul Holberton
Produced by Scala Publications Ltd
Filmset by August Filmsetting, St Helens,
England
Printed and bound in Italy by Graphicom,
Vicenza

FRONTISPIECE **10** Anthony Claesz, *Gouda
Tulip*

TITLE PAGE Detail and whole of **13** Jan
Davidsz de Heem, *Flowerpiece with wooded
landscape*

THIS PAGE **31** Katsushika Hokusai, *Balloon
flowers*

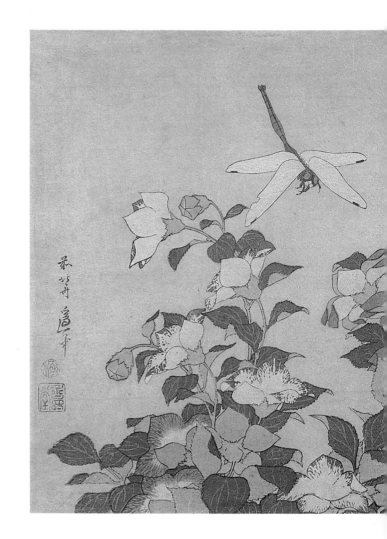

Contents

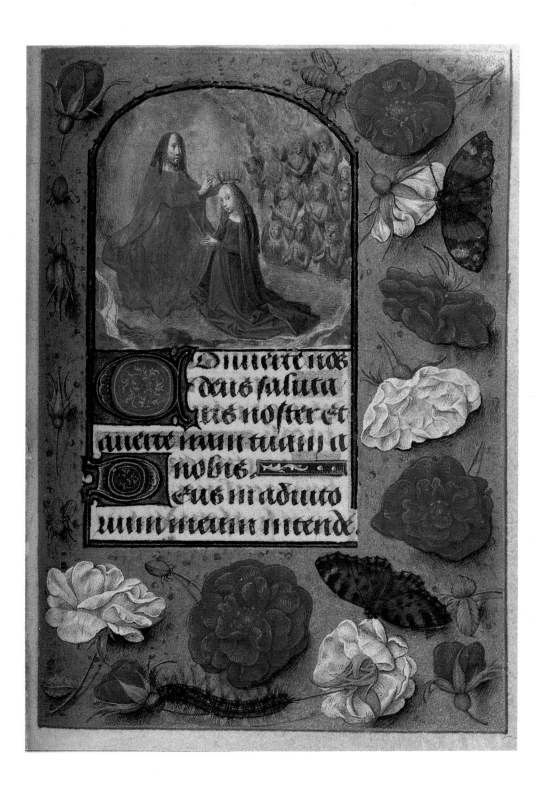

Introduction

What more innocent subject for the painter than the flower! Yet flower painting is gently deceptive. Before looking at the exciting emergence of flower painting as an independent genre and its later development, some weeds of misunderstanding should be pulled away. Flower painting is part of the genre called still life, the painting of inanimate subjects, which, until the present century, was the Cinderella genre. Hoogstraaten, in the seventeenth century, called its practitioners "the foot soldiers of art," a sentiment echoed from academic pulpits of every kind. Whereas history painting, the highest genre, demanded of the artist imagination and creativity to bring to life the heroes of antiquity, the flower painter was merely copying what he saw before him.

This confusion with pure *trompe l'œil* was understandable. The traditional flower painter was clearly trying to produce an accurate likeness and would have been as delighted as his predecessors in ancient Greece if an onlooker had reached out a hand to brush away a dew drop from one of his petals, or if a bird stubbed its beak on the canvas trying to peck one of his fruits. The flower painter faced the same dilemma as any other artist—how to convey the three-dimensional on a two-dimensional surface. The means available to him are more restricted than the repoussoirs against diagonals vanishing to the horizon of the landscape painter. The need to create a convincing space in which the bouquet can stand will be a constant point of reference.

Whatever the academics, not least Sir Joshua Reynolds, may have said of its lowly status, painters from Caravaggio to Manet knew the flower to be as demanding as any other subject, real or imagined. John Ruskin felt it almost beyond reach. Again, despite official disfavor, the popularity of flower painting with the public and the quality of its patrons seldom faltered. Occasionally, the artists themselves weakened. In nineteenth-century France, where flower painting was not even taught at the Ecole des Beaux Arts in Paris, and could provoke refusals from Salon juries, Fantin-Latour, for example, wrote: "I have never had more ideas than now and am obliged to paint flowers. While doing so I keep thinking of Michelangelo!"

The artist before his subject, gazing intently over his palette, and constantly checking his work against reality, is a strongly rooted image. Flower painters in their studio are portrayed in this traditional way. But this is not a true picture of the creation of the majority of the paintings illustrated in this book. The specialist flower painter of the seventeenth and eighteenth centuries made very accurate watercolor studies from nature, trying to keep abreast of new importations and variants, and including, of course, the supporting cast of moths, butterflies, insects, fruits and those crystal vases, jeweled objects, that were not studio props and only borrowed once perhaps. Armed with this repertoire, the artist then composed his imaginary bouquets. Tulips of early spring appear with late

1 Master of Mary of Burgundy
Page from the Douce manuscript, 1485–90
Illumination on parchment
Oxford, Bodleian Library
Careful shading within the petals and for the shadows cast on the light backgrounds produced a *trompe-l'œil* effect in the fine manuscripts of the 14th and 15th centuries. The effect is heightened by the apparently casual scattering of the flowers and insects, and the contrast between their informality and the ritual, religious imagery.

summer roses, an impossible quantity of stems somehow fit into the neck of a vase and the whole bouquet never topples over. Thus, these flower bouquets are a deception, real in every part but, in the sum of the parts, unreal.

We, too, require imagination to look at the flowerpiece through seventeenth-century eyes. There could scarcely be a greater contrast than to today. Flowers are so readily available to us to buy, to see, to grow, to study, that they seem commonplace. In the Low Countries in the seventeenth century, the cradle of flower painting, gardens were the preserve of the wealthy. In so densely populated a country, land was scarce and few houses in cities could boast a garden. While the rich burgher attended to trade in Amsterdam, his staff tended the garden adjoining his country home and cultivated the costly bulbs that he had purchased for it. The rich or banquet pieces of de Heem are obvious displays of wealth, *pronk*, with gold chalices, silver ewers, jewel caskets, greenhouse fruit, silk velvets, and so on. Flowers were viewed in the same way. We know that the value of the blooms could exceed the cost of having them painted, even by one of the prominent specialists. Indeed, the major figures among the "foot soldiers" were some of the best paid of artists. In 1606, the States General paid Jacques de Gheyn 600 guilders for a flowerpiece to offer to the visiting queen Marie de' Medici. So closely linked are gardens and the origins of flower painting in the late sixteenth century that it has been said that the first flower painting was commissioned by a lady to preserve the triumphs of her green-fingered skill in her garden. It seems more likely that the painters saw a potential market and took the initiative.

In order to look upon flower paintings with seventeenth-century eyes, we will also need to be aware of symbolism. By then, flowers had acquired a bewildering array of associations, often contradictory. The rose of pagan love, so liberally scattered in Botticelli's *Birth of Venus*, was transformed by the early Church to a royal flower, attribute of Mary, Queen of Heaven. The grapes of Bacchic revels had become a symbol of the wine of the Eucharist, often accompanied by a symbol of the bread of Communion, such as the ear of wheat (12). Healing plants were readily linked to salvation, any thorn-bearing plant to the Crown of Thorns and the suffering of Christ. An Annunciation could scarcely be painted without a white lily, symbol of the Virgin's purity. The white lily was one of the few exotic flowers grown in monasteries to decorate churches and chapels. A Nativity often included violets (humility) and columbine (the Dove of the Holy Spirit) as in Hugo van der Goes's Portinari altarpiece in the Uffizi, Florence (see, in this series, *The Nativity*).

The remainder of this book could be devoted to two topics, and still, of course, not reach conclusions, since clear documentary evidence is absent. Firstly, to what extent were flower painters themselves aware of these associations as they painted their bouquets? Secondly, to what extent did the onlooker or patron expect to find hidden messages and, if he did, was their content sufficiently ambiguous to allow individual interpretations? The popular emblem books of the period gave certain flowers clear symbolic identity, such as the sunflower turning toward the sun as man should toward God. The opium poppy was equally unequivocal. But it is otherwise usually not so clear.

What was unquestionably part of flower painting was the theme of *vanitas*. "Vanity of vanities, saith the preacher, vanity of vanities, all is vanity. What profit hath a man of all his labor which he taketh under the sun? One generation passeth, another generation cometh but the earth abideth for ever." The

message was clear to a Bible-reading nation. The Reformed Church urged the Dutch to set no store by the vanities of our brief, earthly life, and to consider rather the eternal life to come. Flowers, with their short life, were perfect symbols in themselves of transience, as supported by several biblical passages. Those who paid high prices for them were afflicted by *vanitas*. Flower painters easily found subtle variations of transience. The lizards and flies (**8**) await the unimportant earthly body while the soul in the guise of the butterfly is liberated to fly heavenwards. Amid the freshness of Bosschaert's bouquet (**6**) we find leaves eaten by caterpillars, or with van Aelst (**14**) a watch to remind us of fleeting time.

The salient point is that conventions were established for flower painters that continued to be followed, and expected, long after the symbolism behind the convention had been forgotten or lost its significance. Even if symbolism was considered, it was always subordinate to good composition and artistic integrity. We do not enter our sitting room and see a bird's nest next to a vase of flowers. That is not naturalistic. The bird's nest of van Huysum (**18**) was a symbol of new life, i.e. resurrection. On the other hand, did his sophisticated clients of the 1720s concern themselves with such matters? Did they feel troubled that their wealth extended to the vanity of such costly possessions as a van Huysum? To the artist, the challenge of exploring each straw, lichen and feather of the nest was concern enough. The contradictions of *vanitas* are self-evident. Were these brilliant works a justified celebration of the growing wealth of the proud new nation and a rejoicing in the wonders of God's creation? *"Ex minimis patet ipse deus"* (God is manifest in the most insignificant creature). Or were they a warning against the temptations of this world?

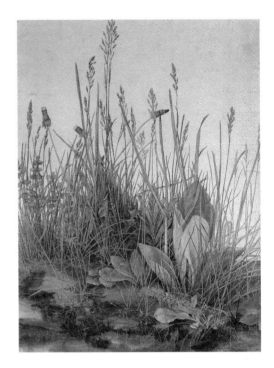

2 Albrecht Dürer (1471–1528)
Das Grosse Rasenstück (*The large piece of turf*), *c*1503
Watercolor on paper, 41 × 31.5 cm
Vienna, The Albertina

The plants shown are salad burnet, dandelion, meadow grass, great plantain, and yarrow. Dürer's watercolors are regarded as the first botanical masterpieces and perfectly reflect the approach to art he wrote of: "... study nature diligently. Be guided by nature and do not depart from it, thinking that you can do better yourself. You will be misguided, for truly art is hidden in nature and he who can draw it out possesses it."

Prelude to the first flower paintings

The birth of flower painting was dramatic. It burst from the soil like some mighty bulb, quick to blossom and flourish. Flowers, depicted by man since the Egyptians, had first been studied out of necessity because of their medical properties (**3**). In a manuscript (**1**) they are better observed and recorded than in most herbals and decorative applications. Flowers lend themselves well to painting in water-based pigments with vellum as an enduring support and an ideal surface, whether the plates were to be bound as a herbal, florilegium, or botanical work with accompanying texts, whether before or after the advent of printing. The use of watercolor on vellum and the reproduction of the results, matched by a commentary of equal merit, were to reach an apogee with Redouté (**23**).

The moment when, for the first time, the flower could become the subject of a painting is inseparable, of course, from the intellectual progress of the sixteenth century. The birth of flower painting is best followed in the Low Countries but the humanist thinking of the Italian Renaissance and the spirit of scientific naturalism in Italy were influential there. Scientists and therefore botanists were encouraged by the example of Francis Bacon and his contemporary thinkers to reject received wisdom and make their own observations of nature. The convalescent Dürer (**2**) observes and records in this spirit, and Hoefnagel (**4**), whose motto was "Nature as the sole master," was an influential forerunner of Savery in the learned court of the Hapsburg Emperor Rudolf II.

At a time of rapid strides in philosophy, medicine, astronomy, exploration, and the diffusion of knowledge through printing,

3 William Turner (1510/15–68)
New Herball, 1568, "Of Sage"
London, Courtesy of the Trustees of the Victoria and Albert Museum
William Turner, the father of English botany, is recognized as the first Englishman to study plants scientifically.

4 Joris (Georg) Hoefnagel (1542–1600)
Page from a *Model Book of Calligraphy*, 1591–96, text by the Imperial scribe, Georg Bocskay
Watercolor and gouache on vellum, 16.6 × 12.4 cm
Malibu, John Paul Getty Museum
With the cosmopolitan Hoefnagel, the accurate depiction of flowers and insects in 16th-century miniatures reaches its apogee.

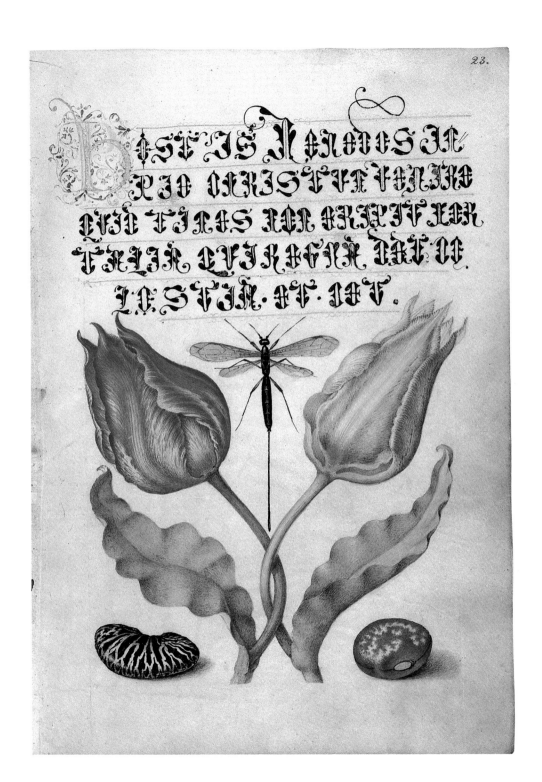

men's minds were freed to look upon the flower as an object of beauty rather than mere utility. In the context of flower painting, the philosophical and scientific spirit of the period is exemplified by the career of Clusius, or Charles de L'Ecluse, pioneer naturalist, botanist, and horticulturist. Born at Arras in 1526, he studied medicine in Germany and Montpellier, but did not practice as a doctor. His passion was for knowledge. He wanted to explore and study not only the plant world of Europe, but the ever-increasing unknowns arriving from newly discovered parts of the world. His attitude and enthusiasm are summed up in the preface to his *Rariorum Plantarum Historia* (Account of Rare Plants) published by his friend Plantin in Antwerp in 1601, in which he says, "to discover many plants unknown to Antiquity was like digging up a great hidden treasure." Clusius also published the results of his travels in Spain, Portugal, Austria, and Hungary, laid out gardens (of which Emperor Maximilian II's in Vienna was the most famous), and came, at the end of his long life, to have three hundred correspondents, all flower enthusiasts, among them the gardeners of Middelburg, home of Ambrosius Bosschaert the Elder. It was, however, his introduction of the tulip, among other bulbs and tubers, from Asia Minor, that caused his greatest fame. He was also the author of the first treatise on the tulip, and his name is perpetuated in the tulip *clusiana*. He must represent here the close links between botanist and painter, between science and art that are a vital and continual part of the story of flower painting from the outset.

Part of that history is the continual introduction of new plants into Europe, often resulting in a craze for them, for example for the camellia in nineteenth-century France—see the illustration by Redouté (**23**), an artist, incidentally, greatly indebted to the botanist

L' Héritier at the start of his career. However popular the chrysanthemum was later with the Impressionists, or the camellia with Dumas, there has been no parallel in later times to the phenomenon of the tulip. The supposedly calm Dutch became so obsessed about the tulip that a market developed in bulbs in which thousands of guilders were paid for a single bulb, with whole properties pledged, and lost, in a frenzy of speculation on a par with the English South Sea Bubble a century later. Gardens were raided and consignments *en route* to Clusius at Leyden disappeared. The viral condition that caused the flame or stripe in the tulip was not understood and upon the "break" of a bulb fortunes were made and lost. Artists like Anthony Claesz (**10**) recorded the appearance of the bulb for tulip books, the forerunners of the printed color catalogs we receive today through the mail. These drawings could also serve painters who wished to add tulips to their oils. Printers were kept busy turning out emblems ridiculing the folly (and vanity, of course) of those gripped by tulip-mania. Until the crash of 1637, it is not easy to find a Dutch flower painting without a tulip, but even after the financial collapse, tulips remained popular and, in some cases, still very costly.

5 Jacques de Gheyn II (1565–1629)
Flowerpiece, signed and dated 1612
Oil on copper, 58 × 44 cm
The Hague, Gemeentemuseum
Through his training with Goltzius, de Gheyn was a superb draughtsman and engraver, who turned to flowers first in watercolor and then, about 1604, in oils. The modest fritillary, lily of the valley, and forget-me-nots are given a central place in a bouquet dominated by tulips and large roses. The whereabouts of de Gheyn's large 1615 bouquet, the third known oil by the artist, is intriguingly unknown but it is thought to be in England.

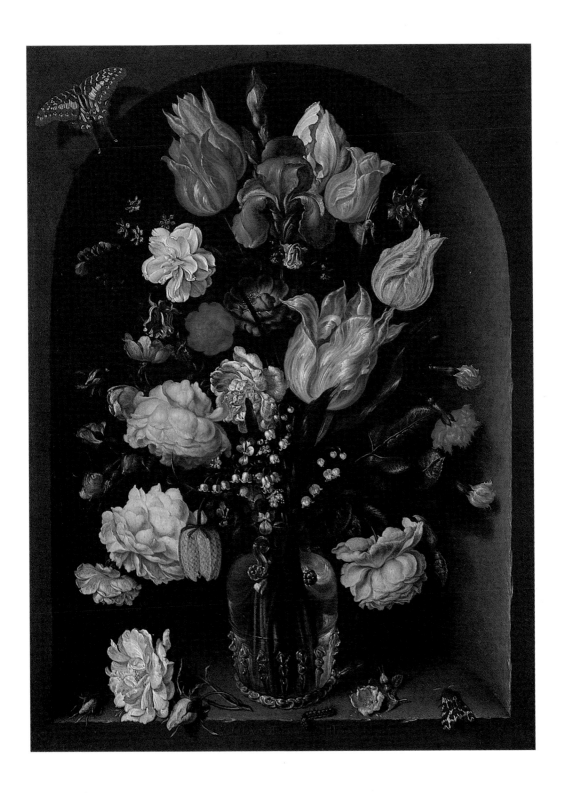

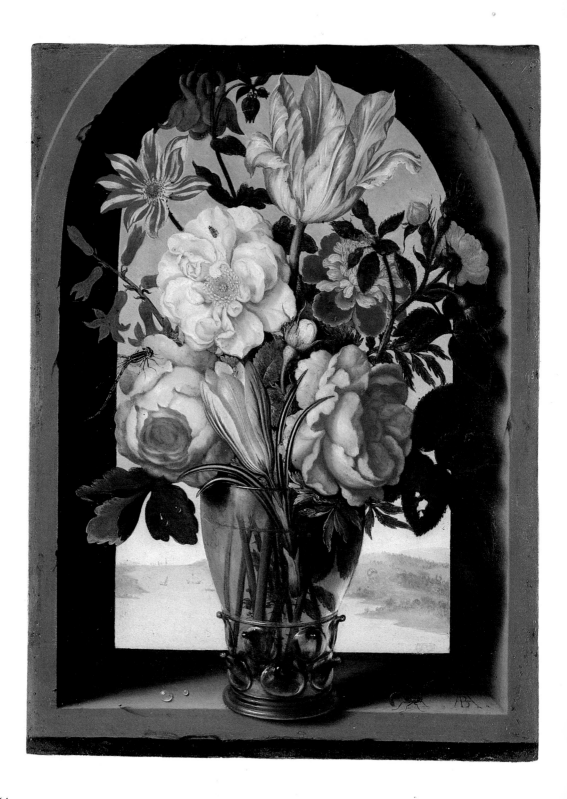

14

The early founders

The founders of flower painting were a mixture of specialists, like Bosschaert and his brother-in-law, van der Ast, who devoted themselves exclusively to flowers and fruits, and artists like de Gheyn, Brueghel and Savery, for whom flowers formed only a small part of their œuvre. In the case of Jacques de Gheyn, he had been mainly an architectural designer and an engraver of allegorical subjects, until his arrival in Leyden in 1595. Under the influence of Clusius, he made watercolor studies of great beauty and naturalness on vellum, which were bound into an album. Among studies of individual flowers, he composed a simple bouquet of three tulips and a fritillary with insects in front of the vase, much reproduced as the earliest dated flowerpiece (1600). The album (now in the Institut Néerlandais, Paris) was bought by Emperor Rudolf in 1604, together with a large painting. Because of the latter's loss, and the survival of only three flowerpieces, we do not know his earlier style. In his large copper of 1612 (**5**), he has departed from the style of the watercolor studies to an ambitious, Mannerist approach with tulip petals flickering like flames and a sense of tension throughout, as if the thrusting flowers would break out of the stone niche in their exuberance. According to his friend

6 Ambrosius Bosschaert the Elder (1573–1621)

Flowerpiece, **signed in monogram**

Oil on copper, 22 × 17.5 cm

Paris, Louvre

One of the rarest flower paintings in existence, this was a far-sighted acquisition by the Louvre. Among museums, only the Getty has followed their example so far (1983) with the purchase of Bosschaert's 1614 copper of a basket of flowers.

Constantijn Huygens, secretary to the Stadtholder, de Gheyn was on his mettle (no pun intended) "to snatch the laurels from Brueghel and Bosschaert both of whom were very famous." The carefully observed shadows against the stone niche and the white reflection of the light through the vase into shadow on the right are typical of the painter's concern to create a convincing space for this large bouquet.

The Spanish occupation of Antwerp in 1585 caused many families to flee northwards. Among them was Ambrosius Bosschaert the Elder whose first period was spent in Middelburg, capital of Zeeland, then Utrecht (1616–19), and finally Breda for the last two years. The mystery remains why no painting by Bosschaert is known with a date earlier than 1605. Indeed, the exact chronology of flower painting will probably never be known as it seems to begin simultaneously in Antwerp, Utrecht and Middelburg, and not one word survives from the mind of Ambrosius. His small bouquet in the Louvre is one of only five examples with an open background (**6**), a device which he was unique in using at this period. Bosschaert's technique is one of enamel-like glazes, worked up slowly to the point where evidence of hand and brush disappear. The mood is one of tranquillity and simplicity, the glass with the prunt decoration perfect in color, translucency, and in the amount of stems it contains.

Jan "Velvet" Brueghel was a Flemish painter who remained in Flanders and achieved fame throughout Europe. His technique is obviously in complete contrast to that of Bosschaert, his slightly younger contemporary, and the comparison is easily made at the Kunsthistorisches Museum, Vienna, where their works hang side by side.

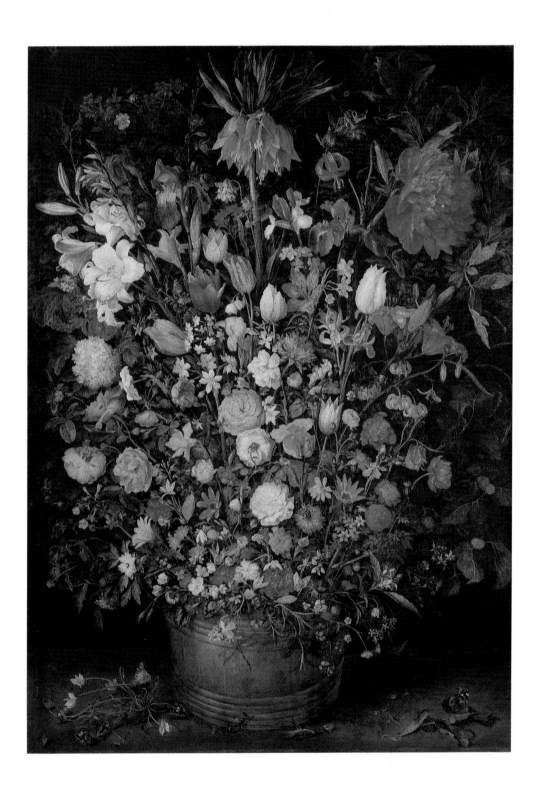

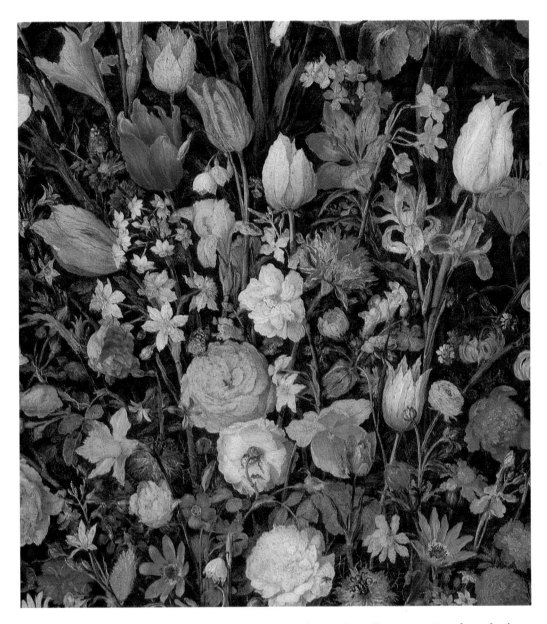

7 Jan Brueghel the Elder (1568–1625)
Flowerpiece, c1606/7
Oil on panel, 98 × 73 cm
Vienna, Kunsthistorisches Museum

The Kunsthistorisches Museum has one of the major collections of the work of Jan Brueghel, including three flower paintings from the first decade of the 17th century. Brueghel wrote to his patron, cardinal Federigo Borromeo, "that never before have so many rare and diverse flowers been painted nor with such painstaking care."

Through, perhaps, a combination of the influence of his miniaturist grandmother and his painterly father, the famous Pieter Bruegel the Elder, Jan acquired a technique of great speed and great surety of line and touch, without which the size and scope of his autograph output would be inexplicable, whether in landscapes or flowers. The detail (7) shows his "drawing" in the wet paint with the white of the priming providing a transparent, luminous effect to the colors. Flowers flowed from his brush, whether they were simple bouquets of a few flowers in a glass, or complex garlands around figures by his friend Rubens (e.g. in the Louvre), or mighty panels such as the Kunsthistorishes Museum panel (7). It is as if a black-and-white page from a printed, early florilegium had come to life in glowing color, the whole imbued with Flemish vitality. The crown imperial lily lends itself perfectly to the role of top flower but the humblest field flower has its place among the exotica. The cyclamen clump is an inspired detail below. This magnum opus is not the isolated achievement of a special commission but, incredibly, one of a dozen variants of which the largest is in Munich. Here are over two hundred flowers of forty different species, the largest assembly of flowers since van Eyck's Ghent altarpiece of 1432.

Roelant Savery, like Bosschaert, left his native Flanders for the north in 1594. By 1604, he had achieved sufficient fame to be summoned to the service of Rudolf II in Prague, the year of this fabulous patron's acquisitions from de Gheyn. So began Savery's fifteen years of travel and work in Prague, the Tyrol, Vienna, Munich, and Salzburg, returning to the Netherlands from time to time and finally settling in Utrecht in 1619. Savery is represented here (8) by his best-preserved and finest flowerpiece, dating from the year of Rudolf's death, 1612. Volume is

achieved by strong chiaroscuro, with flowers looming out of the very dark background, without the stone niche he favored, as used by de Gheyn in his slightly larger bouquet of the same year (5). The variety of flowers may be an allusion to the four seasons just as the Four Elements may be present, in the insects (Air), the ground-hugging mouse (Earth, see detail), the lizard (Fire), and the vase (Water). To the sophisticated court such hidden messages would have been stimulating. Savery's output was mainly of landscapes and animals and there are less than twenty flowerpieces known today. Nonetheless, he was an influential founding figure.

The three sons of Ambrosius Bosschaert were also specialists in flowers and fruits, but

8 Roelant Savery (1576–1639)
Flowerpiece, signed and dated 1612
Oil on panel, 49.5 × 34.5 cm
Vaduz, collection of the Prince of Liechtenstein
The contrast with de Gheyn's bouquet of the same year (5) shows the highly individual content, characteristic of most of Savery's mysterious flowerpieces. In this bouquet, for example, dead nettle, fennel, comfrey, male fern, greater celandine, and field gladiolus have been identified.

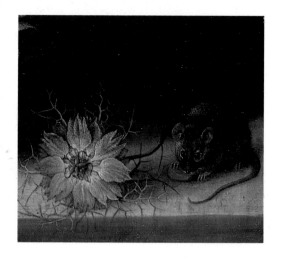

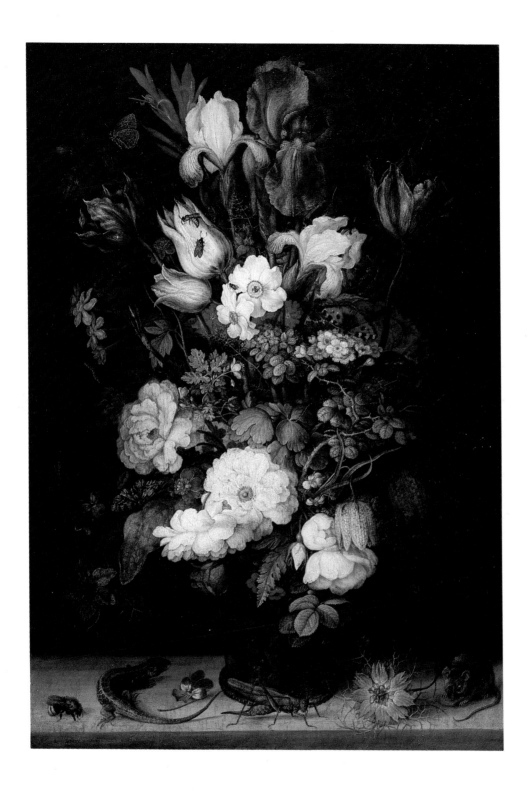

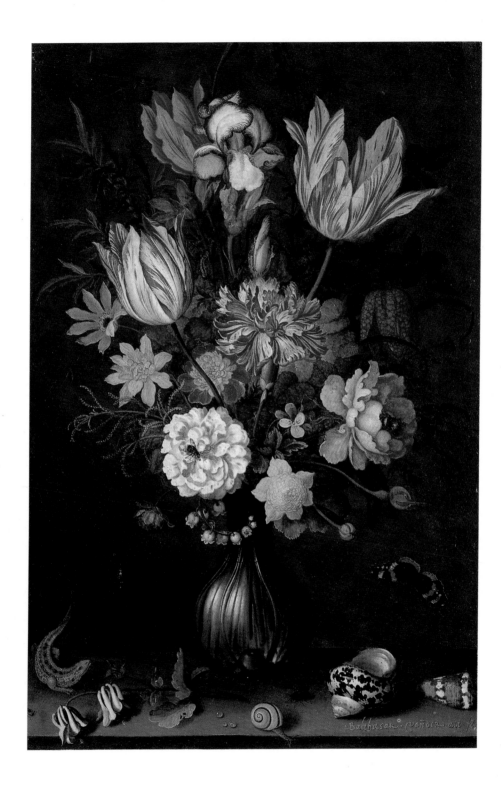

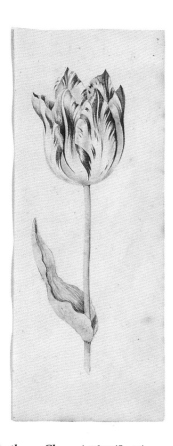

10 Anthony Claesz (c1607/8–49)
Gouda tulip
Watercolor on vellum, 26.2 × 10.6 cm
London, courtesy of Peter Mitchell, Esq.

In 1987 the Noortman Gallery discovered a
book of 56 tulip drawings, from which this leaf
comes, and made it the occasion of an
exhibition where one stood surrounded by
painted tulips.

9 Balthasar van der Ast (1593/94–1657)
Flowerpiece, signed
Oil on panel, 55 × 35.5 cm
Private collection, courtesy of John Mitchell & Son

Only van der Ast, among the Bosschaert
dynasty, was accorded a proper life span. He
developed the range of possibilities with
bouquets, fruit pieces, shell pictures, and
combinations of all of them. Preservation is the
key to the beauty of this luminous panel.

his most important protégé was his younger
brother-in-law, Balthasar van der Ast (**9**).
Orphaned in 1609, van der Ast naturally came
under the care of Bosschaert, whose influence
is obvious. In 1619, however, van der Ast
joined the guild at Utrecht, the same year as
Roelant Savery. It is the latter's influence that
is also apparent in this undated bouquet in a
ribbed vase. There is a looseness and airiness
here that is important for the future. Van der
Ast was partial to shells, collector's items and
reminders of the Dutch overseas empire, and
often included them in his bouquets. He
painted a pair of small panels of flowers and
fruits, now on loan to the National Gallery,
Washington, but once in the collection of
Princess Amalia van Solms, thought to be the
earliest example of such a pairing in Dutch art.

The characteristics of the early flowerpiece
are clear. The container is centrally placed, the
bouquet is contained in an oval outline with
few stems disturbing the symmetry. Overlap-
ping is minimal so that each flower may
clearly be seen, rather akin to a contemporary
group portrait where each patron had paid an
equal amount and wanted to get his money's
worth. Lighting creates both space and mood,
whether tranquil or agitated. The bouquets
have an innocent and joyous quality of their
own, never again to be found in flower paint-
ing, as it becomes steadily more sophisticated.
The founders' standards of observation,
painterly skill, fidelity to nature in detail, and
inventiveness were an example to all later
painters. Their children, in the case of Bos-
schaert and Brueghel, and their other fol-
lowers carried their styles and standards far
into the seventeenth century. The emphasis
given to them here is a reflection not only of
the rarity and status of their works today but
of their importance in the wider history of
flower painting, and through their travels in
the diffusion of a new type of painting.

Among the many artists of the early decades influenced by Jan Brueghel, Daniel Seghers occupies a special place (**11**). Brueghel rendered the Catholic world a great service by converting Seghers back to that faith, since he became a Jesuit and devoted the great majority of his work to garlands, swags, and the like, surrounding votive images for churches and chapels throughout Europe. His works, which could not be purchased, were the Order's gifts to the crowned heads of Europe, including Charles II of England, who visited his studio in 1649 during his exile. As a result of the demand for his garlands, his secular flower paintings are less than twenty in number. The perfect preservation of this example allows us to see the beauty of the impasto and brushwork, painted in an informal mood, wholly convincing, and more akin to Manet (**33**) than to Seghers' contemporaries.

Just as the young Seghers had arrived in Antwerp, and come under the influence of Brueghel, so, in his turn, did Jan Davidsz de Heem follow the example of Seghers. De Heem, whose first teacher in Utrecht was van der Ast, was destined to become the most important still-life painter of the seventeenth century. His work encompassed every type of still life from the small, simple bouquet (**12**) to banquet pieces of immense complexity on seven-foot canvases. De Heem spent his career in Holland and Flanders and allied the two traditions in the course of a long and immensely productive life. This small bouquet dating from the late 1640s became the most valuable flower painting of the seventeenth century ever to have been sold at auction when it appeared in 1987. A combination of Dutch sensitivity to tonal and atmospheric qualities and vibrant Flemish color are immediately apparent. Stems are flowing freely, setting up patterns and hints of the "S" curve to

come in the second half of the century. The bumble bee was a favorite tour de force of de Heem's (**12** detail) and reappears in another important example recently on show in the Mauritshuis in The Hague (in the exhibition *Boeketten uit de Gouden Eeuw* [Bouquets from the Golden Age], 1992). The ability to create new formats and enlarge the scope of flower and still-life painting is seen in this Walt Disney-like fantasy (**13**).

One of de Heem's many pupils, Abraham Mignon, followed this formula and, later, so did Rachel Ruysch. She was also impressed by the work of the appropriately named Otto Marseus van Schriek who developed a horror-movie version of the outdoor scene while working in Italy in the 1650s. His plants, thistles, herbs, and toadstools, set in mossy ground deep in the forest, are illuminated by a ghostly, unreal light. Beneath, the ground abounds with snakes, lizards, toads, and the like, as in the de Heem. In a plot of ground outside Amsterdam, van Schriek nurtured his own specimens; it must have been a rather sinister allotment. The accuracy of detail throughout allied to the surreal effects of the whole was a successful innovation, echoed in later periods. Van Schriek also painted conventional bouquets of which the best known is dated 1661, formerly in the Linsky collection, New York.

11 Daniel Seghers (1590–1661)
Flowerpiece, signed
Oil on copper, 56 × 40 cm
Private collection, courtesy of John Mitchell & Son
The contemporary poet who wrote of Father Seghers that "he paints flowers so life-like that the hand reaches out to gather them," was, for once, justified. In a cool light, against an impenetrable blue-gray background, the flowers stand fragrant, elegant, and make us believe we smell the jasmine and that the gecko will be gone in another second.

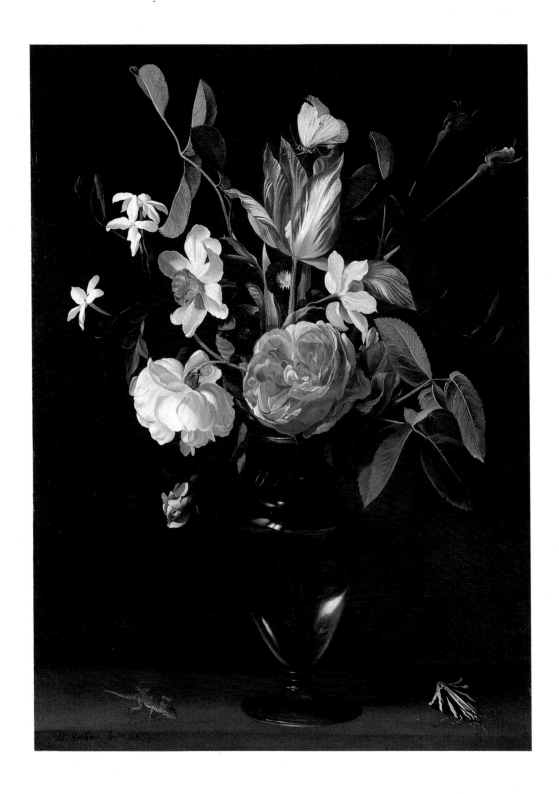

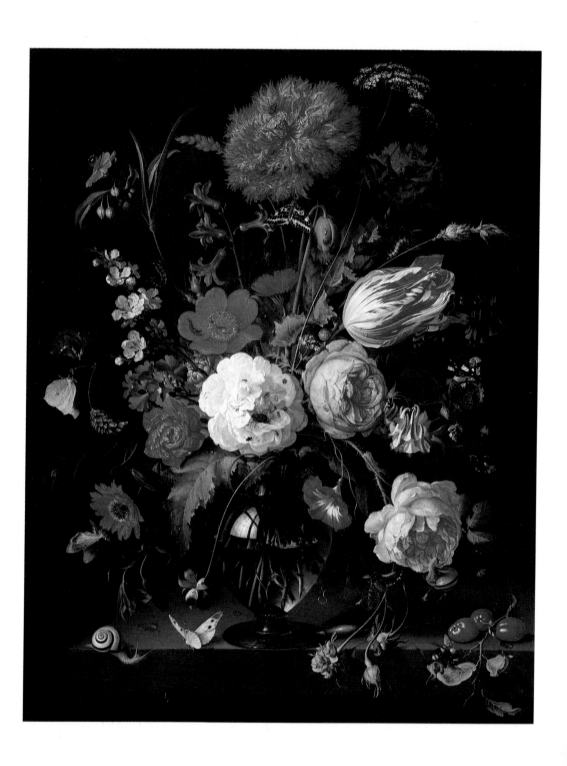

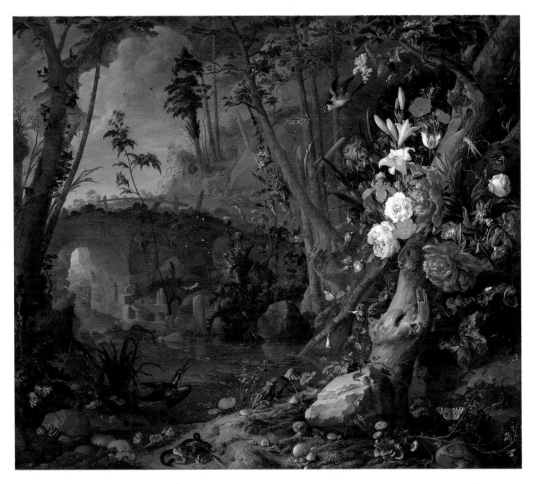

12 Jan Davidsz de Heem (1606–83/4)
Flowerpiece, signed
Oil on copper, 48.5 × 38 cm
Private collection, courtesy of John Mitchell & Son

No better example could be given of the line of
development from Brueghel, through Seghers,
to de Heem than the juxtaposition of these
works (12 and 13). The comparison is sound
because both are on copper and of similar size.
This de Heem is the finest example in private
ownership.

13 Jan Davidsz de Heem (1606–83/4)
Flowerpiece with wooded landscape, signed
Oil on canvas, 113 × 131 cm
Vaduz, collection of the Prince of Liechtenstein

One of the delights of the recent (1991) de
Heem exhibition, this large canvas speaks for
itself. The tree (see detail) was copied by
Rachel Ruysch and the whole composition by
Mignon, who may indeed have contributed to
the de Heem.

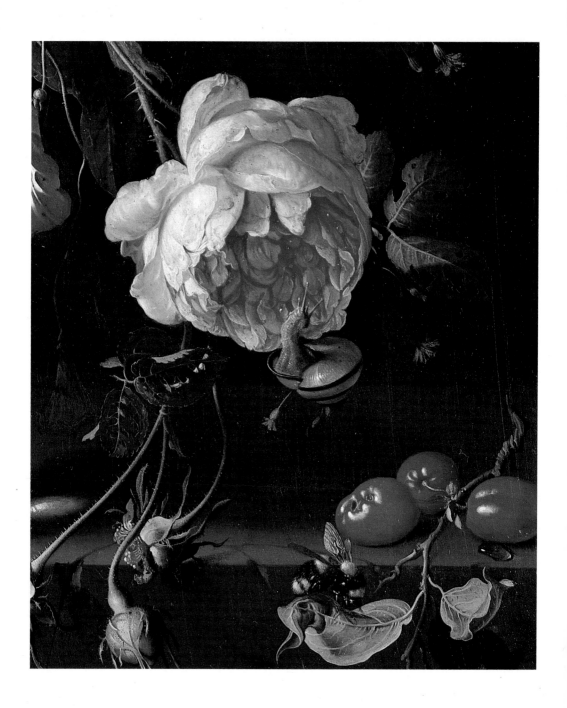

Details of 12

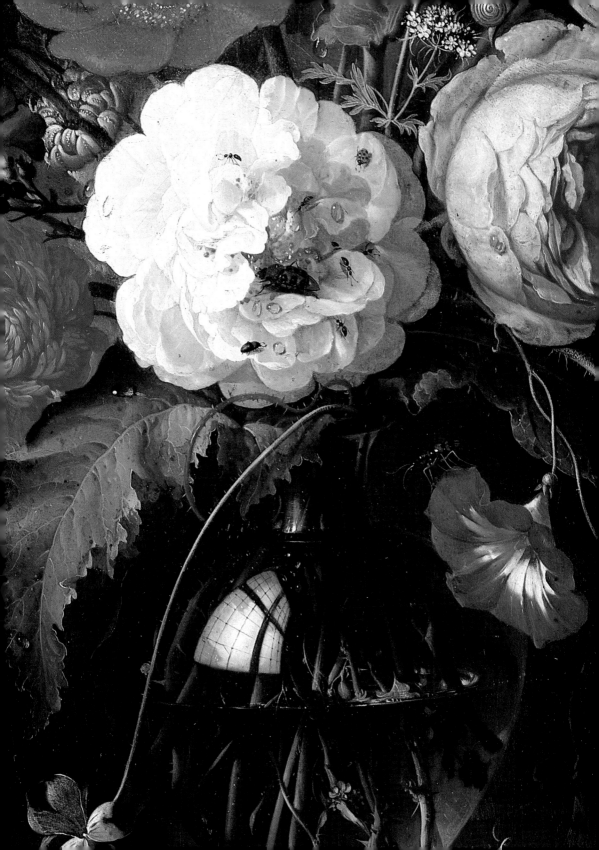

The eighteenth century

One of the artists impressed by van Schriek was Willem van Aelst who worked with him in Rome and also enjoyed the patronage of the grand duke of Tuscany. After his return to Amsterdam in 1657, he continued to sign himself "Guglielmo"to remind patrons of the breadth of his education. Van Aelst's masterpiece of 1663 (**14**) is little more than a decade after de Heem's (**12**) but shows a rapid development of the compositional ideas latent in de Heem. It is a significant moment in the theme of flowers. The bouquet is built on the strong diagonal from the variegated carnation, lower left, to the poppy, top right, and flows freely over the edge of the table top balanced by the blue ribbon. Comparing the de Heem and the earlier masters, we see the wooden and stone ledges replaced by marble, glasses by a silver vase, the symmetrical by the baroque, simple shells by an ornate pocket watch. The transience of the watch is echoed in the withered leaf and the black fly on the snowy white of the snowball (viburnum). The mood throughout is one of elegance and sophistication.

Two years after van Aelst's bouquet, Jean-Baptiste Monnoyer's membership of the French Academy was confirmed (1665). With the support of Lebrun, tsar of the arts in France, Monnoyer embarked on a career of dazzling splendor. In the Europe of the second half of the seventeenth century, there was no greater prestige than the patronage of Louis XIV. In the French interior, where the decor is planned as an entity of which every element forms a part, Monnoyer succeeded brilliantly in adopting flowerpieces to this end. In a typical picture (**15**) the abundant flowers sit naturally in the grandeur of the setting. The flowers do not lose their individuality but their decorative role becomes paramount. Monnoyer

14 Willem van Aelst (1625/26–after 1683)
Flowerpiece with watch and ribbon, **signed and dated 1663**
Oil on canvas, 62.5 × 49 cm
The Hague, The Mauritshuis
The combination of the silver vase by Lutma and the silver gilt watch with the blue ribbon, with a huge poppy as top flower, was an immediate winner. The versions in the Ashmolean Museum, Oxford, and San Francisco show how easily a skilled flower painter could vary a successful design.

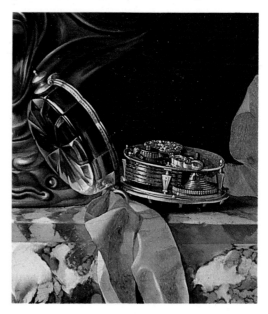

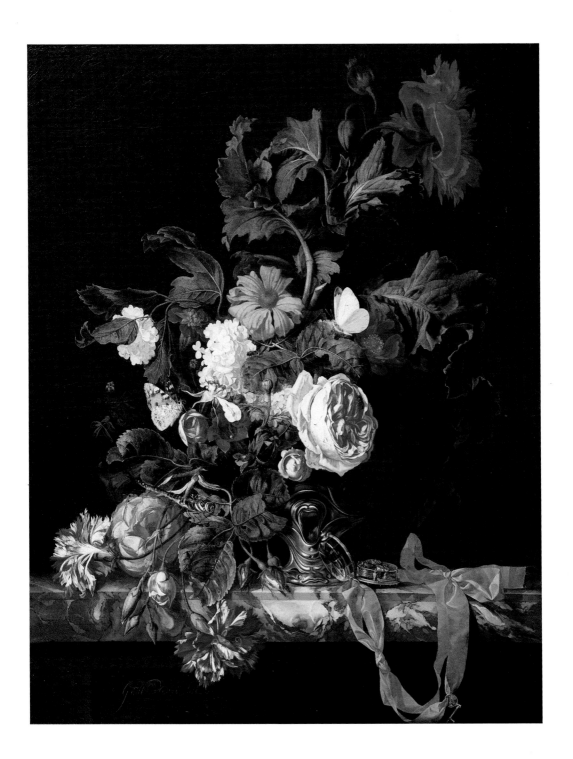

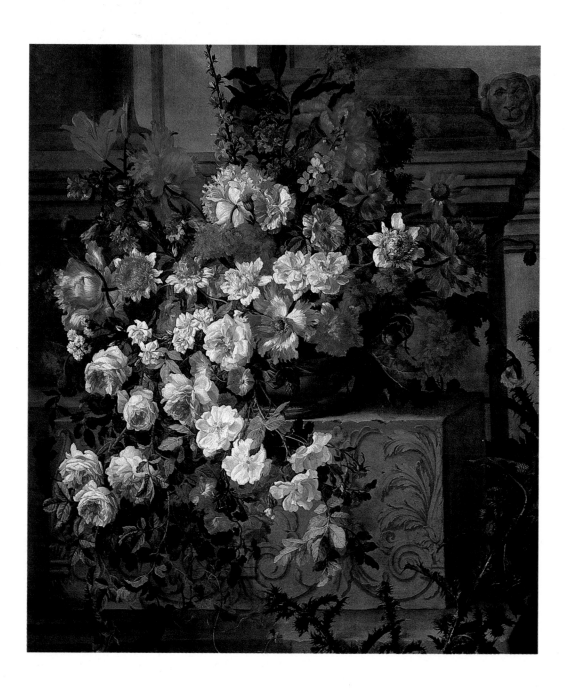

15　Jean-Baptiste Monnoyer (1636–99)
Flowerpiece

Oil on canvas, 105 × 92 cm
Private collection, courtesy of the Richard Green Gallery

**Monnoyer was one of the team of French
artists employed by the duke of Montagu at his
great house in Bloomsbury, later to become the
British Museum. In this task, his early
biographer, d'Argenville, considered that the
artist surpassed himself.**

met the huge demand for this work with the help of his son, his son-in-law, Belin de Fontenay, and a considerable studio. Sixty pictures were supplied to Versailles alone, and more to other royal residences at Vincennes, Meudon, and Marly. To the Gobelin and Beauvais tapestry works went floral designs and borders of many kinds. The aristocracy was not slow to follow the king's lead, and through the English ambassador, the duke of Montagu, Monnoyer became as popular in England as in France. Inevitably his name has been devalued by the mechanical products of his lesser studio hands, especially when he so rarely signed his paintings. Nonetheless, in his autograph work, Monnoyer set an example to the whole of Europe in the refinement of drawing and palette in decorative flower painting. His much-copied book of engravings *Livre de Toutes Sortes de Fleurs d'après Nature* inspired countless painters, designers, and flower arrangers.

Van Aelst's pupil, Rachel Ruysch, was the most famous woman flower painter and, at her best, one of the greatest specialists of either sex. This bouquet (**16**), once a Rothschild treasure and exhibited at the British Institution in the nineteenth century, shows her penchant for reds, oranges, and pinks, often in pale shades, her velvety brushwork, and subtle through lighting. The design of this large and complex bouquet is indicative of her innate good taste and sense of refinement. The use of silhouette against the stone niche is masterfully handled. Düsseldorf has a unique collection of her work today, thanks to her appointment as court painter to the Elector Palatine Johann Wilhelm in 1708.

The cleaning of one of the finest examples of the work of Ruysch's younger contemporary, Jan van Huysum, has recently been completed (**18**). The sudden appearance on the market of a panel, obscured by discolored

or collapsed varnish, like a diamond in the rough, is an unfailing excitement to auctioneers, dealers, restorers, collectors, and historians—a faint echo, perhaps, of the stir caused by the introduction of new flowers in the past. Clearly, Rachel Ruysch and van Huysum mark the transition of the flowerpiece from the seventeenth century to the eighteenth century, but the younger artist took the stylistic tendencies that we have followed to a far greater development and, indeed, apogee than could have been envisaged. In flowers, van Huysum is the ultimate sophistication. He banished the dark or blank background of the seventeenth century, throwing it open to a vista of a gentleman's estate with fine trees and classical statuary. He also lightened the whole tonality and palette with relief-ornamented terracotta vases adding to the range of flower colors. Van Huysum succeeded in the perfect adaptation of the flowerpiece to the rococo age, yet, incredibly, maintained the most exacting standards of the early masters in technical excellence and fidelity to the individual specimen. The onlooker may probe the most slender stem of a modest bloom only to find it drawn with assurance and rhythm and rounded with light and shade throughout its length. The detail here should be an encouragement to examine the originals, especially in the Wallace Collection in London.

In contrast to the finish in oils, the preparatory drawings show the rapid and effortless massing of volumes and the fixing of the fall of light, using black chalk with watercolor washes added afterwards. The drawing (17) in the Louvre was for a panel, of comparable size, now in a private collection in England and once in the collection of the late duke of Kent. The contemporary fame of this secretive and jealous artist was awesome and, unlike that of most flower painters, never waned. Suffice to

16 Rachel Ruysch (1664–1759)
Flowerpiece, signed
Oil on canvas, 73.7 × 64.2 cm
Toledo (Ohio), Museum of Art
Rachel Ruysch, who became van Aelst's pupil at the age of fifteen (1679), painted flowers into her eighties, with her latest dated work in 1747. The many poems and eulogies devoted to her were, perhaps, in admiration for her successful combination of the roles of artist, wife, and mother (ten children), if that is not too modern a viewpoint.

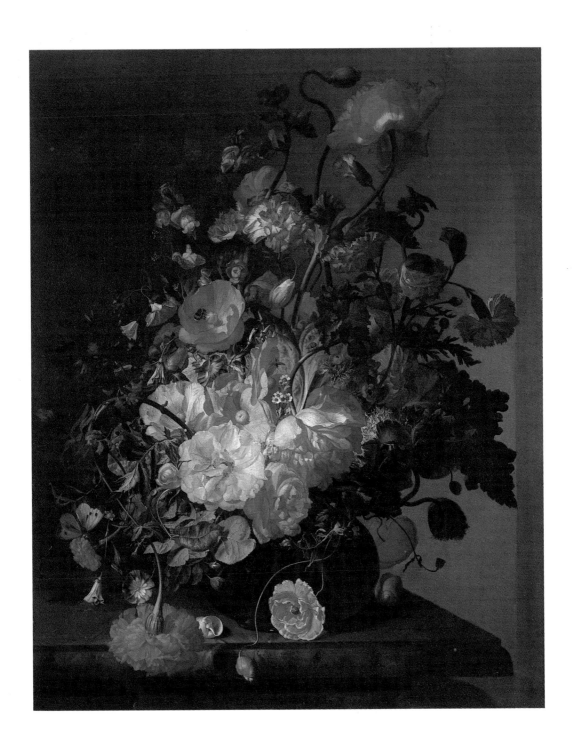

33

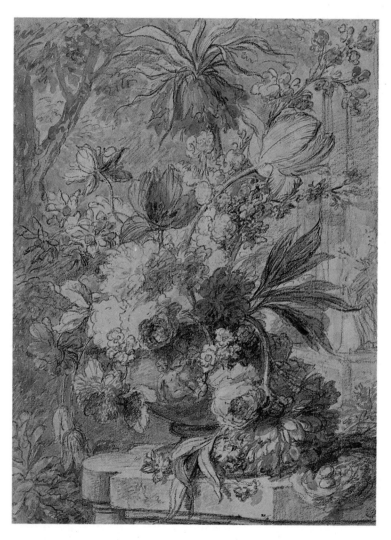

**17 Jan van Huysum
(1682–1749)**
Flowerpiece
Black chalk and watercolor
on paper, 47.5 × 35.6 cm
Paris, Louvre

This drawing, once in
the French royal
collection, is a guide to
dealing with the
difficult question of
attribution. For
example, many of the
drawings in the British
Museum are clearly by
his younger brother
and imitator, Jacob.

**18 Jan van Huysum
(1682–1749)**
Flowerpiece, signed,
*c*1730
Oil on panel, 80 × 61 cm
New York, courtesy of
French & Co

I am grateful to Martin
Zimet for allowing his
recent acquisition to be
reproduced here for the
first time after cleaning.
Decades have passed
since an example of
this caliber was
available. Ordinary
mortals are no nearer
to the possession of
such a masterpiece than
they were in van
Huysum's day.

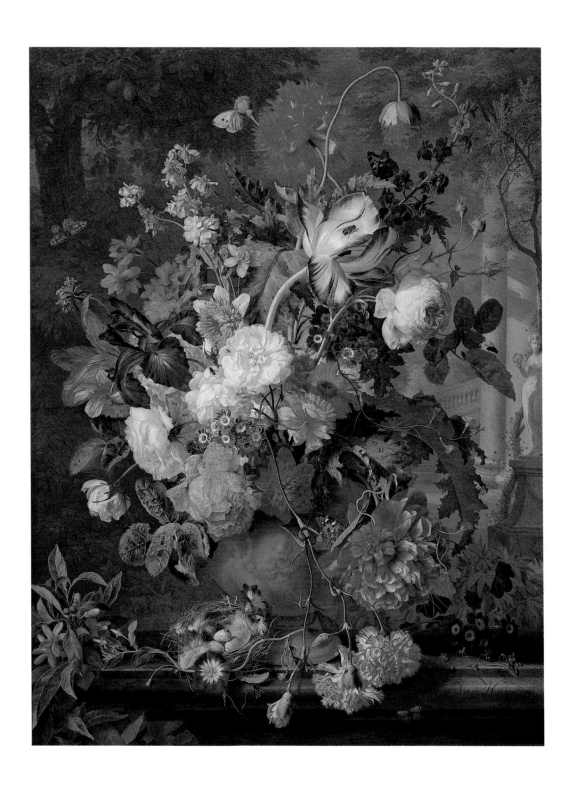

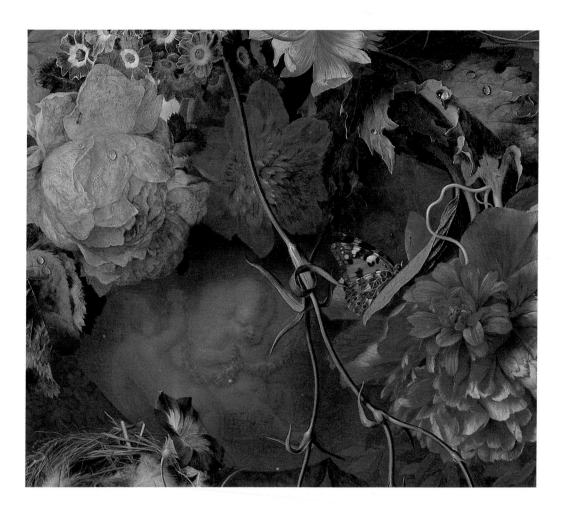

Detail of 18

say that no serious traditional flower painter of whatever nationality, in the eighteenth or nineteenth century, would take up his brush without reference to van Huysum.

The most celebrated van Huysums in England belonged to Sir Robert Walpole at Houghton Hall in rural Norfolk, before the pair were sold to Catherine the Great. The house has recently been in the news through the sale to the National Gallery, London, of its famous Holbein. With the departure of the Holbein, the *White duck* by Jean-Baptiste Oudry is now probably the most important painting at Houghton, an extraordinary sym-

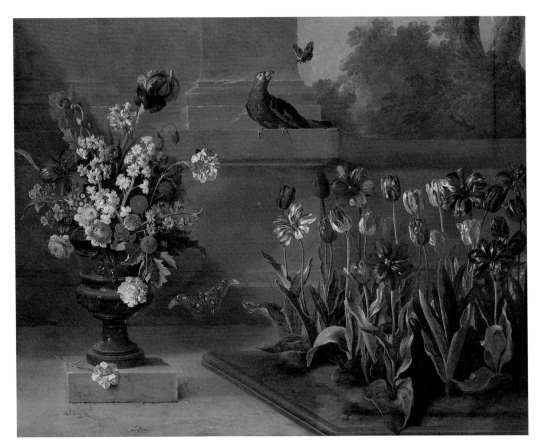

19 Jean-Baptiste Oudry (1686–1755)
Flowerpiece with a bed of tulips, signed and
dated 1744

Oil on canvas, 146 × 181 cm
Detroit, Institute of Art

**The unprecedented exhibition of Oudry's
works in 1983 showed his mastery of the
hunting still life, fruits, flowers, landscapes, and
live animals—a superb heir to the Flemish
masters of the 17th century, Snyders and Fyt.
The Detroit example is outstanding.**

phony in whites. Although Oudry's teacher,
Largillière, placed great importance on still life
and flowers in the instruction of young
painters, few examples are known from either
master. Thus, this corner of an elegant French
garden by Oudry (**19**) is a rarity in an œuvre
devoted to *"trophie de chasse"* pictures with cats
usually in evidence. Cut flowers arranged in a
formal bouquet in an urn are juxtaposed with
live tulips gaily growing in their parterre
while a butterfly teases an exotic bird. Oudry
and Desportes brought a freedom and French
elegance to formulas of Flemish origin with,
here, a delicious *plein-air* effect.

How great a contrast between the aristo-
cratic overtones of Oudry and the bourgeois,
domestic poetry of Chardin twenty years

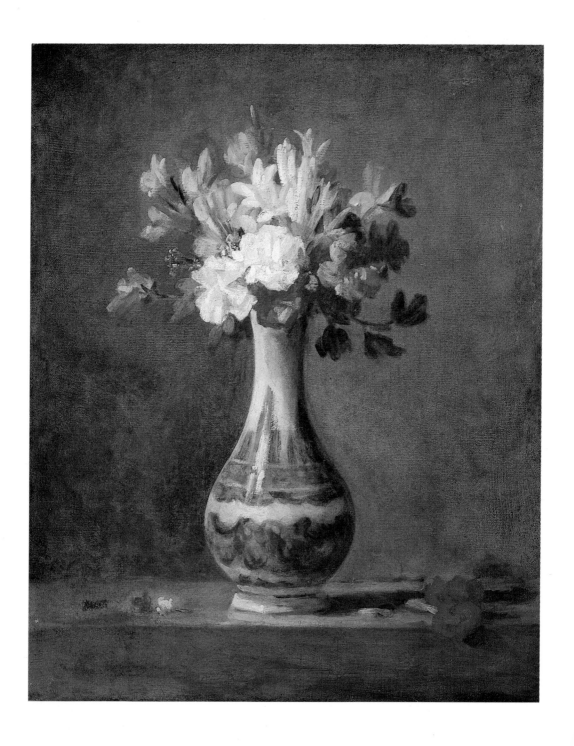

20 Jean-Siméon Chardin (1699–1779)
Flowerpiece

Oil on canvas, 43.8 × 36.2 cm
Edinburgh, National Gallery
of Scotland

Diderot wrote of
Chardin, at about the
time of this unique
flowerpiece, "This is
unfathomable wizardry.
Thick layers of color
are applied one upon
the other and seem to
melt together. At other
times one would say a
vapor or light foam had
breathed on the
canvas.... Draw near,
and everything flattens
out and disappears;
step back and all the
forms are recreated."

21 Jean-Baptiste Huet (1745–1811)
Lilacs, signed and dated
1786

Oil on paper mounted on
canvas, 40 × 31 cm
Private collection, courtesy
of John Mitchell & Son

Huet was primarily a
painter of pastoral
landscapes and idyllic
scenes so that this
brilliant study may
come as a surprise. The
paper gives a
distinctive surface.

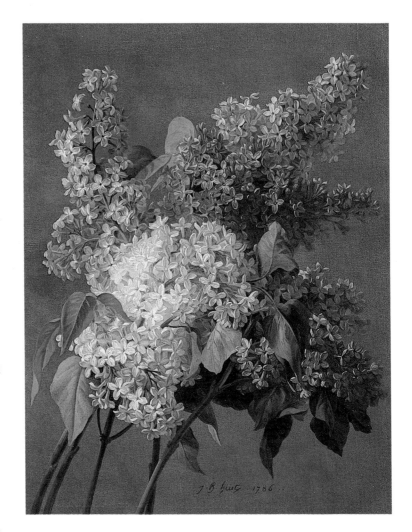

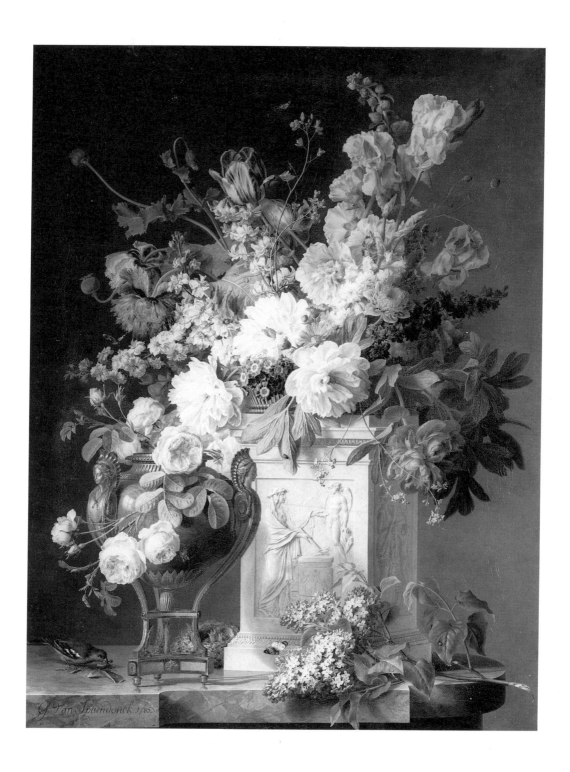

22 Gerard van Spaendonck (1746–1822)
Flowerpiece, signed and dated 1785
Oil on canvas, 117 × 91 cm
Fontainebleau, Musée du Château de Fontainebleau
For this royal commission, Spaendonck was
allowed to use an ormolu-mounted vase from
the king's collection to set off the pink roses.
Visitors to the Salon of 1785 rightly marvelled
at this masterpiece.

later. Of the four recorded flower paintings by the mature Chardin, one of which was exhibited at the Salon in 1763, only the Edinburgh example is known (**20**), a unique painting and a unique achievement. The Flemish tradition had guided Chardin's earlier, anecdotal, kitchen still lifes. Gradually he moved towards a simplification of subject matter, where interval is as important as object, with a "Dutch" concern for tranquillity, light, atmosphere and pure painting. Together with so many painters of the *ancien régime*, Chardin was forgotten in post-revolutionary France. His revival in the nineteenth century is a well-documented phenomenon, which influenced the approach and technique of many artists, not least the Lyonnais school, led by Antoine Vollon. Fantin-Latour and Manet echoed the feelings of Diderot about the supreme technical mastery that Chardin possessed. The simplification of forms, and the power of such abstraction, as seen in this bouquet, were lessons not lost on Cézanne.

In the second half of the eighteenth century, the center of flower painting moved from the Low Countries to Paris. The demand for flower painting there could not be met by French artists alone and, not surprisingly, the Dutch and Flemish went where the patronage was. From Antwerp, Jan Frans van Dael was the important figure, but the way was led by Gerard van Spaendonck, the true heir to van Huysum, who went to Paris in 1769. His progress was spectacular. In 1774, he was appointed miniaturist to the newly crowned Louis XVI, in 1777 he made his Salon début, and in 1780 he was appointed professor of flower painting at the Jardin des Plantes. Spaendonck was the master of all mediums from the five-centimeter circular miniature bouquet for the top of a Sèvres porcelain box, painted in gouache, to a full-size formal Salon piece in oils (**22**). The twenty-four plates of

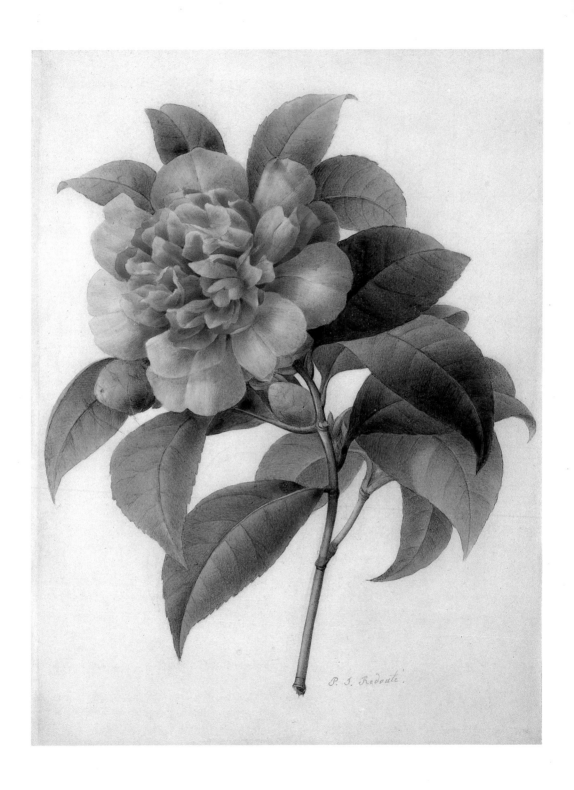

P. J. Radouté.

his *Fleurs dessinées après nature* are among the most beautiful of all flower engravings and were widely influential. Spaendonck, in common with other flower painters, worked without interruption from the *ancien régime* to the Bourbon restoration, so it is not surprising that this picture, a royal commission of 1785, hangs in the Napoleonic suite at Fontainebleau. In working for the Vélins du Roi, the royal and subsequently national collection of studies on vellum started by Louis XIII's brother, he changed from the traditional gouache to pure watercolor. Van Spaendonck was as great a teacher as he was an artist and hundreds of artists followed him in the course of the nineteenth century. His combination of Dutch technical mastery and sensitivity to flowers with French elegance was all-conquering.

The lilac which van Spaendonck placed in the foreground of his composition (**22**) was a favorite flower in France. To remind ourselves again how an artist could, at will, include a flower in a composition, this ravishing oil study from nature by Jean-Baptiste Huet of 1786 is timely (**21**). Perfectly preserved and rivalling the quality of van Spaendonck, it is also a reminder that the finest of a minor name is more desirable than the mediocre from a greater name.

Until the last twenty years, van Spaendonck was unjustly neglected whereas his pupil had long been a household name. The countless reproductions of Pierre-Joseph Redouté's prints that decorate hotels and table mats have, however, not contributed to a greater understanding of the artist. Redouté had his equals in watercolor botanical work, such as that by the Bauer brothers, but when it comes to the question of how to lay out a flower for presentation or how to compose an elegant posy of fresh specimens to work from he is, in my view, incomparable. This pink camellia (**23**) has retained its color and freshness and the vellum is free from spotting or blemish. The quality of Redouté's originals was matched by that of the engraving and printing and, in the case of great books, such as the *Lilacées*, by the commentary. He has often been described as being in the right place at the right time. Certainly in Josephine he found an ideal patron and his great books were sent by Napoleon to the dignitaries of Europe as an expression of French culture and excellence at a moment when France was undoubtedly the center of the civilized world. Watercolor painting of flowers on vellum continued as a very strong tradition, whether botanical or otherwise, and the legacy of Redouté remains with us today.

23 Pierre-Joseph Redouté (1759–1840)
Camellia, signed
Watercolor on vellum, 23.5 × 17.9 cm
Private collection, courtesy John Mitchell & Son
The fairy-tale life of Redouté is well known. The boy who left home at thirteen to be a journeyman painter was destined to become one of *the* names in the history of flower painting. In terms of sustained quality through an incredibly large output, he stands alone.

A sample bouquet from the nineteenth century

I n the nineteenth century, the distinction of schools became less important as artistic movements took on an international character. In this period, flowers were subject to the same diversity of treatment as other genres. The traditional approach of the Dutch flourished alongside the work of artists who saw in flowers, as in every other subject, a vehicle for the expression of their own emotions and reactions.

One of the most intriguing artists of the early nineteenth century was, in fact, born in 1754. The mystery of the 89-year career of Antoine Berjon is an obsessional interest of the present writer. Berjon grew up in the service of the silk industry in his native Lyon. Led by the example of Berjon, these draughtsmen/designers became easel painters in their own right, and so the Lyonnais school of flower painting became the most productive and prestigious in France. Berjon worked in Paris and made his Salon début there in 1798. Throughout his exhibiting career, he was unfavorably compared to the great van Spaendonck and van Dael. Berjon was, in reality, a highly original artist who still awaits his proper recognition. This is undoubtedly hindered by the rarity of his work and the few examples available in public collections outside Lyon. The purchase by the Louvre in 1974 of a superb and hauntingly beautiful Berjon was an example to other museums. To date only Philadelphia has followed this lead, and has the only Berjon in a public collection in North America. His role as a teacher was, like that of van Spaendonck, important, and he was also a complete master of the flower in all media. Neither Boilly nor any other artist of the period could better this pastel of peonies

24 Antoine Berjon (1754–1843)
Flowerpiece
Pastel on paper, 62 × 48 cm
Lyon, Musée des Beaux-Arts
Redouté's contemporary, Berjon, was also a consummate master of technique but, unlike Redouté, in every medium. No finer pastel of flowers was painted in Berjon's lifetime.

25 Jean Benner-Fries (1796–1849)
Flowerpiece, signed and dated 1836
Oil on canvas, 165 × 120 cm
Mulhouse, Musée de l'Impression sur Etoffes
Benner-Fries displays a sure grasp of design in this large and ambitious composition, quite different from his conventional easel pictures. How one would like a chintz curtain from his exotic design!

27 Johan Laurentz Jensen (1800–56)
Flowerpiece, signed and dated 1830
Oil on canvas, 92.5 × 74 cm
Private collection, courtesy of Hirschl and Adler
Galleries, New York

Jensen, the father of Danish flower painting, was not thought worthy of inclusion in the recent *Golden Age of Danish Painting* exhibition at the National Gallery, London. At the suggestion of the Danish crown prince, the youthful Jensen went to Sèvres (1822) to receive instruction from Cornelis van Spaendonck.

26 Jean Benner (1836–1906)
Narcissi, signed
Gouache on paper, 47 × 33.5 cm
Private collection, courtesy of Didier Aaron & Co, New York

The purpose of such studies is difficult to ascertain, but they offer a level of quality to the collector today that cannot be matched in oils without straining the budget.

(**24**). It may be that Berjon will one day be seen for what he was, the most important French-born flower painter before Fantin-Latour.

The links between flower painters and the tapestry, porcelain, silk, fabrics, and wallpaper industries are historic but the subject still awaits its historian. The reader is strongly recommended to make the journey to eastern France to visit the Musée de l'Impression sur Etoffes at Mulhouse, and the Zuber wallpaper museum at nearby Rixheim. Shown here (**25**) is the work of Jean Benner-Fries, a pupil of van Spaendonck and van Dael who, after working in Paris and London, became a successful designer at Mulhouse, a center of fabric manufacture specializing in chintz. This large canvas is a masterly conjuring up of exotic faraway places with a bird of paradise (strelitzia) as an appropriate top flower vying with a brilliant red cactus flower. The narcissi (**26**) by his son Jean Benner, in the designer's medium of gouache, is assured, fresh, and stylish with brown paper adding to its distinction.

The Danish-born Johan Laurentz Jensen was so successful in his short career in Scandinavia and Germany that he relied on a studio to meet the demand. He should not be judged by these hard, mechanical productions, nor by the recent over-enthusiasm for all things Nordic, but by his best and most original works such as these growing plants in their pots (**27**) of 1830.

Severin Roesen, one of the best-known American specialists, was born in Germany and would have probably been aware of Jensen's work exhibited there. Roesen went to America in 1848 and soon settled in Pennsylvania, the center of American still-life painting. His strictly "Dutch" traditional approach mellowed into a personal and charming style but his technique continued to show his training as a porcelain painter. His most celebrated

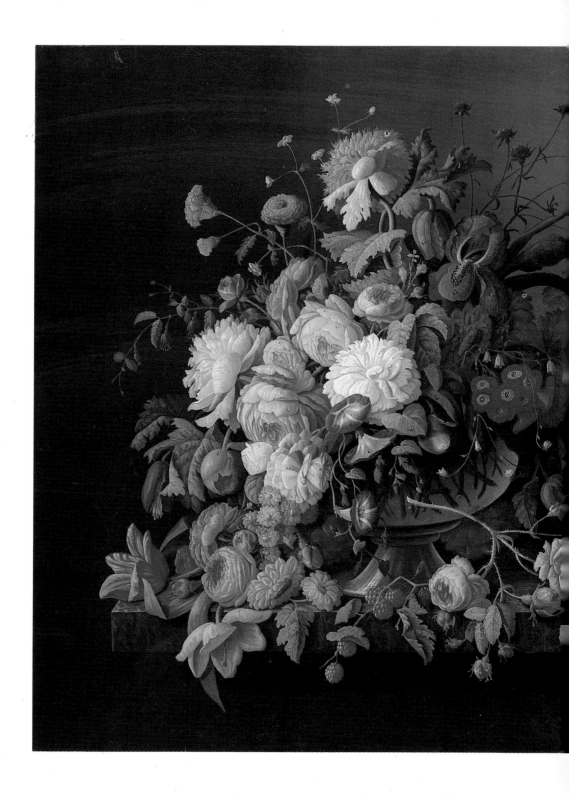

work, in the Metropolitan Museum of Art (**28**), shows the "abundance of nature" approach on a meter-long canvas. The curling vine tendril signature in the lower right was a favorite motif of Roesen's.

Turning momentarily away from the specialists, we know that many artists added flowers of the highest artistic caliber to their own subjects, and by no means in an incidental role.

Unwelcome confidence, the title of Lawrence Alma-Tadema's panel of 1895 (**29**), was a favorite theme, harking back to a work of the same title of 1869, now at Liverpool. This Dutch-born painter's first drawing, at the age of ten, was of tulips, and flowers played an important part in his output thereafter. They are treated, like every archeological detail, every object in the composition, with minute attention, in the spirit of a Pre-Raphaelite and rivaling that other contemporary master of detail, John Frederick Lewis. Frequently, Alma-Tadema made his flowers symbols of love and pleasure, for example *Roses, love's delight*, 1897 (St. Petersburg, Hermitage); and in the *Last roses* of 1872, the poet sings, in a familiar vein of transience, "Like the garland of flowers, thou will bloom and fade." The language of flowers was the subject of many publications at this period. Alma-Tadema's evocation of the Greek and Roman world reminds us that today's buyer of flowers for a loved one follows the most ancient of

28 Severin Roesen (active 1848–71)
Flowerpiece, signed
Oil on canvas, 101.6 × 128 cm
New York, Metropolitan Museum of Art
Roesen's compositions clearly derived from the Dutch tradition via the Düsseldorf school's interpretation of it in the 19th century. The upright bouquet at Houston (Museum of Fine Art) is another very fine example, dating from the 1850s.

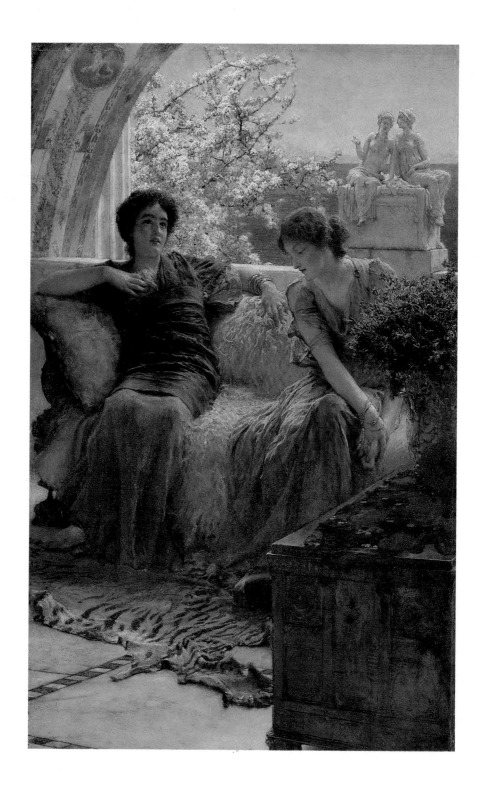

associations—that of flowers and love.

Although the Impressionists only occasionally painted flowers, the results were often so impressive and influential that they are as popular as their characteristic landscapes. In 1869, Renoir and Monet were neighbors in Bougival and often worked together. The two young artists painted the same bouquet of fresh flowers in a blue and white vase. Whereas Renoir decided on a traditional composition with the vase placed centrally and a few fruits to the right (Boston, Museum of Fine Arts), Monet (**30**) placed the bouquet to one side and made a strong structure from the table's horizontal and the lines of the white cloth, taking a "high" viewpoint and cutting off the basket in classic Impressionist style. This early bouquet, so monumental and built up, might be momentarily unrecognizable as the work of the master of floating, ephemeral visions of water-lilies. Monet perfectly demonstrates the evocative quality of flowers: to look at this bouquet is to feel oneself in rural France on a sunny weekend.

Monet, together with most of his contemporaries, was an enthusiast of Japanese art, represented here by one of Katsushika Hokusai's woodblock prints of the 1830s (**31**). Their chance arrival in Paris in the 1850s as the wrapping of a porcelain shipment stimulated the craze of Japonisme, superficially familiar from the penchant of its main devotees, Degas, Monet, and Whistler, for including in their paintings Japanese porcelain, fans and kimonos from their collections. Hokusai's unexpected designs, sometimes elegant, sometimes quirky or compelling, have an obvious affinity with the Impressionists' way of seeing the world and, especially, flowers.

Monet would have acknowledged very warmly the influence of Henri Fantin-Latour. The English, traditionally devoid of good flower painters but second to none in receiv-

29 Sir Lawrence Alma-Tadema (1836–1912)
Unwelcome confidence, signed and dated 1895
Oil on panel, 46 × 29 cm
London, The Maas Gallery

Two pure flowerpieces, *Bluebells* (1899) and *Peonies*, included in the studio sale of 1913 are today unlocated. *Flowers*, now in Boston, was exhibited at Amsterdam in 1869, and earned for the artist elevation to the rank of Knight of the Order of the Dutch Lion from king Willem III.

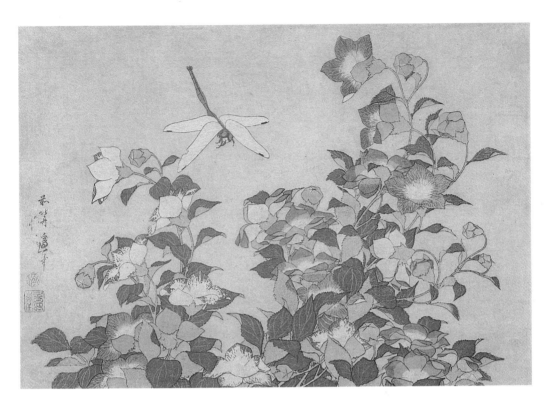

30 Claude Monet (1840–1926)
Flowerpiece, signed, *c*1869
Oil on canvas, 100 × 80.7 cm
Malibu, John Paul Getty Museum

It is appropriate that Impressionism in flower painting should be represented by Monet who devoted so much of his later life to creating his garden at Giverny, and to painting the waterlilies there. The Courbet bouquet of 1862 in the same museum offers an instructive comparison.

31 Katsushika Hokusai (1760–1849)
Balloon flowers (Platycodon grandiflorus), *c*1830
Woodblock on paper
London, British Museum

Hokusai's most famous works were the *36 views of Mt. Fuji*, but his rarer flowers are more appropriate to his influence on the Impressionists. Both Pissarro and Zola felt that Japanese art had anticipated many of the innovations of the Impressionist movement.

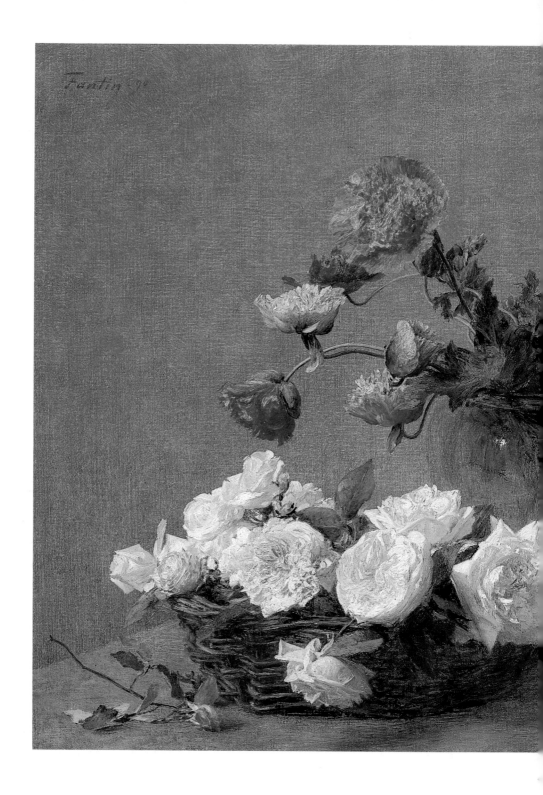

32 Henri Fantin-Latour (1836–1904)
Poppies and roses, signed and dated 1890
Oil on canvas, 60 × 73 cm
London, courtesy of the Lefevre Gallery

In 1909, the *Times* reviewer wrote: "It is in his more intimate feeling for nature and growth and the personality of flowers that the charm of Fantin-Latour's pictures consists. In his chosen apprehension (which is more akin to that of the poet than that of the peeping botanist) the life of the flowers, with what they have of refreshment and consolation to the human spirit, is rendered intelligible and expressive."

ing those from abroad, are understandably proud of having embraced the flower paintings of Fantin-Latour before his compatriots, who preferred his portraits and allegories. Edwin and Ruth Edwards became his lifelong friends and champions from the time of his first visit to Sunbury in 1859, and he soon became a Royal Academy regular, and a much sought-after flower painter. Familiarity has tended, until quite recently, to prevent an objective assessment of Fantin, a shy and meditative man. His marriage in 1876 to Victoria Dubourg, herself a flower painter, gave him the domestic happiness and calm that he so needed. The effect on his output was proof enough. Between 1860 and 1870, he painted about four flowerpieces a year but between 1870 and 1880 he produced over 250. The rose reigned supreme in his work in the 1880s, and, like Redouté, he has been type-cast as "the painter of roses." The picture illustrated here (**32**), long in Britain, is unusual in being on a light background in the later period (1890). The Icelandic poppies take the eye more than the roses but, with Fantin, every freshly cut and arranged flower is given its own presence, individuality, and dignity. It is an unfathomable gift. Fantin-Latour was the heir to Chardin and the greatest flower painter of the nineteenth century.

Edouard Manet also studied Chardin, as a comparison between **20** and this crystal vase of carnations and clematis of 1882 (**33**) makes clear. The sixteen pictures that Manet painted in the last months of his life are among the most spontaneous and direct of all flower paintings. We are all lifted by being brought flowers when ill, but Manet's joy was immortalized. "I would like to paint them all," he said.

33 Edouard Manet (1832–83)
Pinks and clematis, signed
Oil on canvas, 56 × 35 cm
Paris, Musée D'Orsay

Matisse was asked to comment on Manet's legacy on the centenary of his birth and wrote of him as the "first painter to have translated his sensations immediately.... He was the first to act by reflex and thereby to simplify the painter's metier."

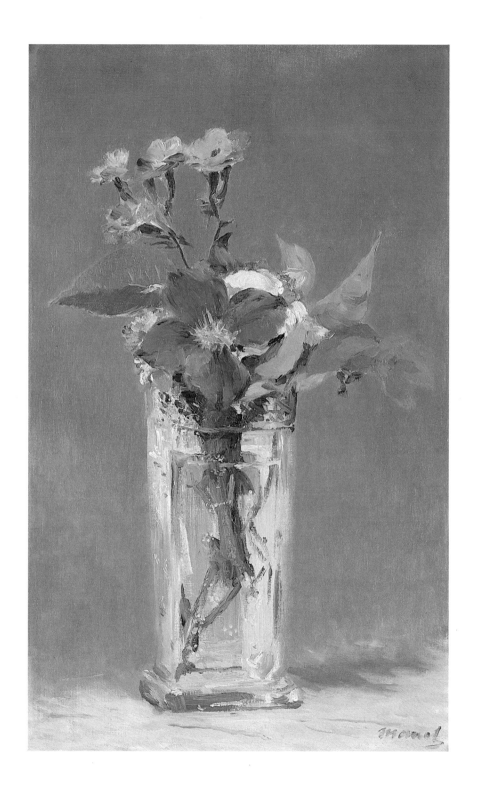

Modern movements
expressed through flowers

Close by the Monet (**30**), in the Getty Museum, hangs the newly acquired *Irises* by van Gogh. This acquisition, although the more costly, came after that of the *Sunflowers* (**34**) and was less sensational, but, suddenly, values in tens of millions of dollars were attached to oil-paintings of flowers, both cut and growing. To the Japanese the opportunity to acquire the *Sunflowers* was uniquely interesting for three reasons. The sun is a national emblem of profound significance to the Japanese. Secondly, they lost a van Gogh of *Sunflowers* in the war and could assuage that memory by replacing it. Thirdly, and most cogently, it was the only example remaining in private hands that was ever likely to come onto the market. The televised interview with the chairman of the company which bought and now displays the *Sunflowers* was instructive in our materialistic age. No mention of money was made, only of admiration for van Gogh, reverent enthusiasm for his *Sunflowers*, and the honor it bestowed upon his company and by extension his country to be in possession of such a very great work of art. His words seemed to echo the attitude of the early founders of flower painting in van Gogh's native Holland. Perhaps they also offer us a proper sense of priorities.

The powerful emotional content of the *Sunflowers* is of a very different order from that of Odilon Redon (**35**), the most complex, original, and mysterious of flower painters. Redon's upbringing near Bordeaux was in isolated and bleak surroundings where his vivid imagination filled the empty landscape. From Rodolphe Bresdin, he learnt both engraving and the potential of working from the imagination. From Clavaud, a botanist, he

34 Vincent van Gogh (1853–90)
Sunflowers
Oil on canvas, 100.5 × 76.5 cm
Private collection, courtesy of Christie's
Though he was scarcely able to sell a single picture in his lifetime, when van Gogh's *Sunflowers* came to auction exactly 134 years after his birth, they instantly secured a place among the best known of all images in art. The artist painted a series of seven paintings of these alluring flowers during his fourteen-month stay in Arles between 1888 and 1889.

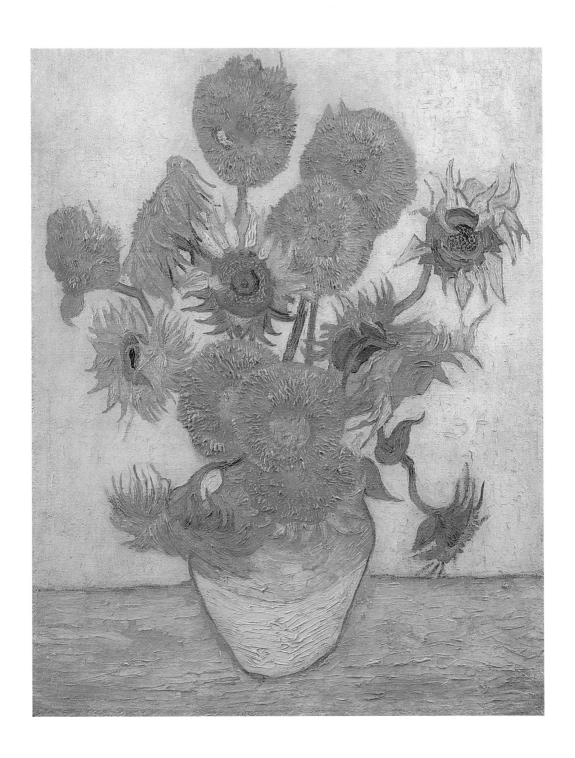

learned to study flowers not only in a conventional sense but as manifestations of a mysterious life-force. However, Redon was prone to mental suffering and self doubts, and it was only at the turn of the century that a transformation took place that freed him to give rein to his sense of color and his love of flowers. He was encouraged by the admiration of the Nabis and Fauves—Matisse bought two pastels in 1900—and by the success of his exhibitions. At the Salon d'Automne of 1905, five out of ten of his exhibits were of flowers in oils and pastels, and he continued with flowers up till his death in 1916. Pastel was an ideal medium for Redon, because it heightened the dream-like quality of the bouquet, that seems both real and elusive. He looked through the physical appearance of flowers to their inner timeless qualities, the soul that the Greeks had sought. Redon wrote of his work that it was "the logic of the visible at the service of the invisible."

At about the time of Redon's Salon success, Emil Nolde was painting his first flower paintings. "It was midsummer. The colors of the flowers attracted me irresistibly and at once I was painting. My first flowers came into being," he later recollected. He came to approach color for its own sake and the intense yellow of these sunflowers (**36**) offered a perfect vehicle for the questing,

35 Odilon Redon (1840–1916)
Flowerpiece, **signed**
Pastel on paper, 47 × 60.5 cm
Private collection, courtesy of Artemis
No flower painter has written more perceptively than Redon, and no apology is offered for repeating a favorite quotation:
"...flowers that have come to the confluence of two streams, that of representation and that of memory. It is the ground of art itself, the good ground of reality, harrowed and ploughed by the spirit."

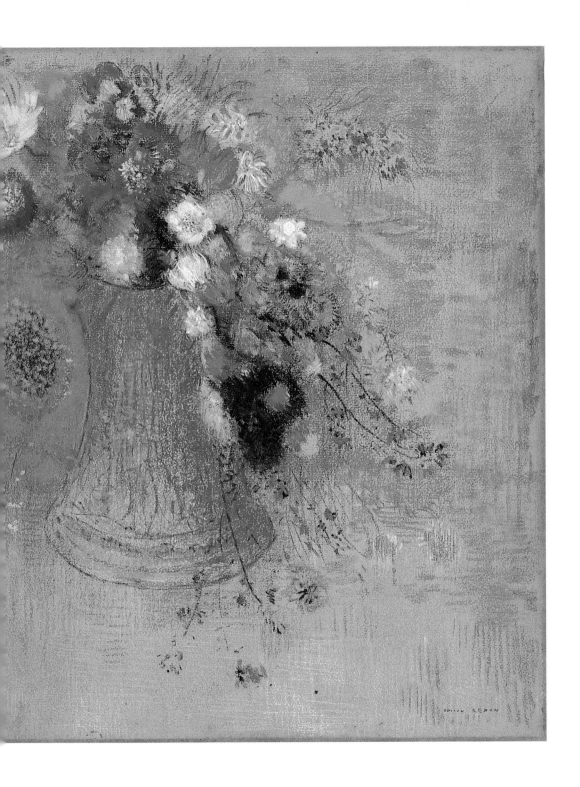

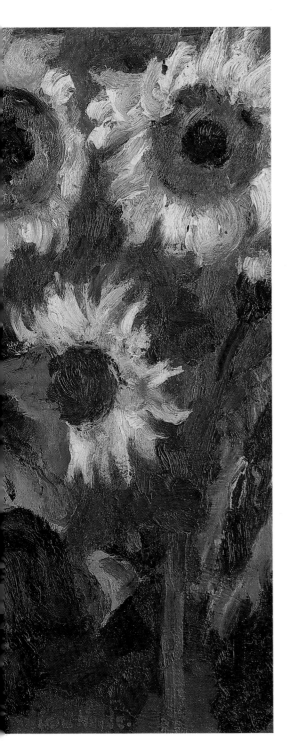

troubled mind of the Expressionist painter. They resemble tapestries, massed, flat areas of color placed in rhythmic patterns; color dominated Nolde's thinking and attracted the admiration of Die Brücke. They are, perhaps, the most easily grasped of his subjects, and the work of a true lover of flowers who continually planted and tended gardens. In common with many artists, Nolde found solace in flowers. In years of struggle he wrote "Whenever I felt that my feet were no longer on the ground, pursuing my romantic or fantastic creations, I would get back to Nature, put down my roots in the soil and humbly use my eyes to render what I saw." Throughout his career, Nolde renewed his profound admiration for van Gogh's *Sunflowers*.

Now that flowers are universally available and surround us in reality or reproduction, are we in danger of taking them for granted? Flower paintings can prevent our doing so because they succeed in focussing our attention upon them more closely than in nature. Is that not the purpose of art? The celebrated American artist Georgia O'Keeffe had her own solution, guided as ever by her inventive inner vision (**37**). "I'll paint what I see—what the flower is to me—but I'll paint it big and they will be surprised into taking time to look at it!"

36 Emil Nolde (1867–1956)
Sonnenblumen II

Oil on panel, 73 × 88 cm
Private collection, courtesy of Fischer Fine Art

These sunflowers are typical of Nolde's finest flower paintings in that they are removed from any environmental relationship; the flowers have no soil or vase, only petals, stamens and a few leaves. "I loved the flowers for their fate; springing up, blooming, glooming, making people happy, drooping, wilting, finally ending up discarded in a ditch. Human life is not always so logical or beautiful."

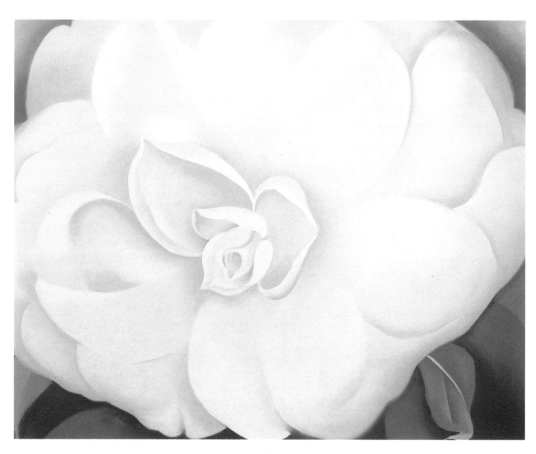

37 Georgia O'Keeffe (1887–1986)
White camellia, 1938
Pastel on paper, 54.5 × 70 cm
New York, courtesy of Hirschl and Adler Galleries

Georgia O'Keeffe infuses her work with such
pulsating life that her flowers seem to billow
like giant sails. The traditional term still life
seems inappropriate for the work of this
remarkable lady, who lived thirteen years
beyond even the long life of Rachel Ruysch.